From The Bench

From The Bench

Ava M Lanes, Author and Photographer

Published by Tablo

Publisher and wholesale enquiries: orders@tablo.io

20 21 22 23 LSC 10 9 8 7 6 5 4 3 2 1

Foreword

I am uncertain what images stick with others, but what I am sure of is that few people find themselves on benches without slowing down. You don't have to go to faraway places to find comfort and tranquility while seated on a bench. I learned, at a very young age, from my mother, Kathryn Odegaard, to love the simplicity in life. She would, on a regular basis, take me on mini tours of her yard and garden so I would have an appreciation of plants and flowers, always ensuring that I knew the names of each. She taught me that same appreciation for birds, butterflies, insects, trees, etc. Additionally, my parents found a way to save enough money to purchase a set of World Book Encyclopedias so that I might educate myself about living things, differing species, their habitats, their unique features, their migration patterns and so on. The remarkable thing about that early learning was that I have carried forward wisdom regarding simplicity. I have grown to appreciate the astounding and noteworthy aspects of the ordinary and the importance of taking time to be still and experience time for contemplation.

There truly is a world of benches out there - enjoy just of few of them in these pages and go out there and find them for yourself!!!

Simplicity In Life

From The Bench: From Where I Sit

I have spent the past twenty five years discovering photography, discovering nature and discovering myself through the camera lens and through my own eyes. I have sat on many a bench and thought why does a bench invite me to pause, ponder and be still? What is it about just taking time to stop, look and listen that changes how I feel? If it elicits those feelings in me, what does the same experience elicit in others? How can I create, via photography, the "take me there" kind of event? And so, I began to take photographs of benches, all shapes and sizes, colors and venues, from different places and spaces.... all in an effort to capture a sense of being there.

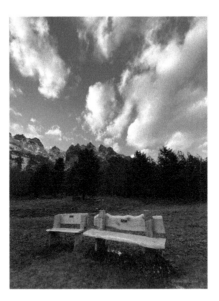

From Where I Sit

Pondering And Penning

From Where I Sit

From The Bench: Reserved

My invitation to you is to take a time out, whenever a bench presents itself, to sit awhile and lose yourself. There is something so very calming about just being idle and being in the moment. Should one choose to do this "idling" on your own bench in your own space, or one that you happen to come across, it is an invitation to ponder and pen. I believe there is a bench somewhere (or anywhere) waiting for you and its signage says, "Reserved Just For You."

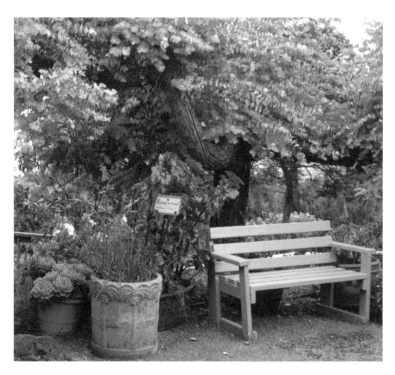

Reserved

Pondering And Penning

Reserved

From The Bench: Winding Down

On any given day, it is easy to not notice your surroundings, to zip
through the day and to not pay attention to nature or to allow yourself
some private time. So, **go out and buy yourself a bench**. Place it
somewhere that brings you enjoyment and peace.... it could be close to
a garden, next to a bird feeder, on a rooftop, facing a park or gazing at a
city skyscraper. It matters not; what matters is that it allows you a sense
of tranquility, a space free from disturbances and a place where you
find a sense of calmness. And guess what? YOU will soon find yourself
winding down

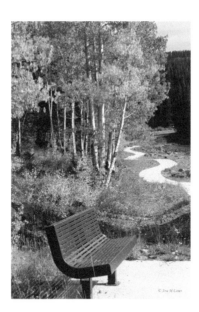

Winding Down

Pondering And Penning

Winding Down

From The Bench: Discover And Awaken

Do you remember a day..... when you climbed the knoll, watched the fog lift and said hello to a new dawning? Do you remember a day.... where you discovered and were awakened with an onset of invigorating thoughts, a fresh idea or a renewed sense of purpose? With a new view sometimes comes a renewed perspective, something that feels like a breath of fresh air as well as a kick-start to a brighter day. Use times like this to jot down those ruminations and then re-read and reflect.

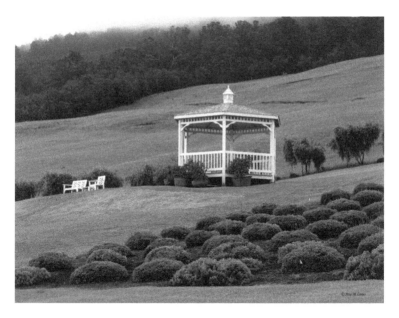

Discover And Awaken

Pondering And Penning

Discover And Awaken

From The Bench: Changing A Blue Day

Experiencing a "down day" or just feeling a bit downhearted? Those hours or days do happen and do transpire for all of us. And the cure? Take a break, grab a cup of coffee, pour a glass of wine and be still…. in the fresh air. Of course, the real medicine, in my opinion, is to find one's way to a bench. A place where you can just be…. focus, examine, scan and take note of what surrounds you; peer into the beauty of nature; pay attention to the sounds around you; feel the breeze or temperature; and look intensely into the sky. Over time and almost always, you can change a blue day just by engaging with time on "The Bench."

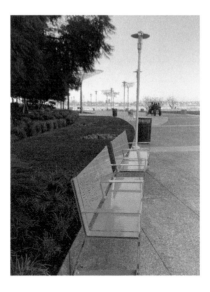

Changing A Blue Day

Pondering And Penning

Changing A Blue Day

From The Bench: Soulful Searching

Soul searching is an honest evaluation of your feelings and/or your motives for doing things. Soul searching or nourishing the soul is an exercise everyone should partake in…. it is a desire to look more deeply for meaning in your life. Some individuals nourish their soul by meditating, some by praying, some by traveling, some by reading, and some by listening to music. No matter the choice, the first ingredient is to spend some time alone. It is not selfish to take time for yourself - it is, in fact, one of the best ways to get in sync with yourself. I find that "alone time on the bench" is not only the first ingredient but the recipe.

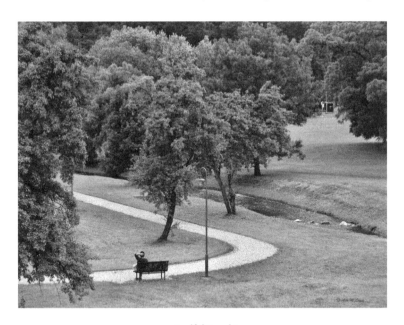

Soulful Searching

Pondering And Penning

Soulful Searching

From The Bench: Light It Up A Little

Whether you prefer glitz and shimmer or whether you like simple and plain, find that small spark inside you and light it up. One of the best gifts you can give yourself is to discover what brings you joy and act upon it. What brings one joy is that spark of ingenuity, that endeavor that brings peace and satisfaction, that event where time just flies. So, it is off to a winter solstice, a midwinter hike, a tree in the wilderness or just a "Happy Place Bench." Go there, wherever "there" is, and light it up just a little!

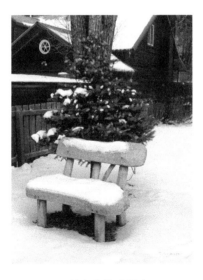

Light It Up A Little

Pondering And Penning

Light It Up A Little

From The Bench: Linger Longer

There are some places, spaces and benches where you might just have an inclination to linger longer…an enduring dwelling place where you want to remain for not minutes, but for hours. It could be a location that you unexpectedly stumble upon and then, you persist in the beauty or you persist just because of how it "feels." I have been there and I remember whispering to myself, "I never want to leave." So, give yourself permission ….. go ahead and linger longer.

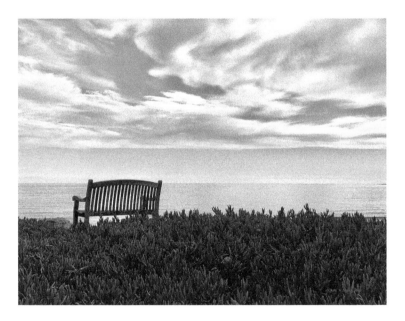

Linger Longer

Pondering And Penning

Linger Longer

From The Bench: Savoring The Scents

Life brings many a delightful and memorable moment. And most of those moments occur unexpectedly in our daily lives. So one day, find yourself a bench and bask in a sensory experience. Think about that old cliché, "stop to smell the roses" and do it. Then suspend time, pause and be still, relish in the moment, and breathe deeply. Instead of delighting in the sense of touch or sight or sound, take note of the fragrance and aromas around you. Take time on that bench, savor the scents and make your own memorable moment.

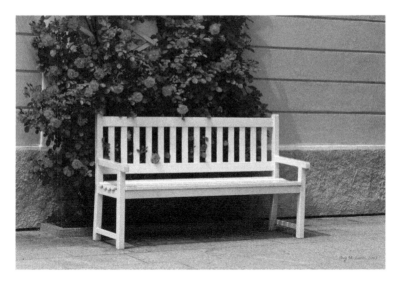

Savoring The Scents

Pondering And Penning

Savoring The Scents

From The Bench: Time Out

An ordinary day, in an ordinary space, can turn out to be an extraordinary experience. When an everyday kind of place, or space, draws you in, don't miss the opportunity to take a welcomed and needed "time out." Just sit awhile on that bench. Study the surroundings, pay attention to the elements, examine the locality and feel the ambience. You will soon discover there is magic in the ordinary. Any day and every day becomes a "day of choice." What I soon realized from many a time on a bench is that an ordinary experience is what I make of it..... choose to make it extraordinary!

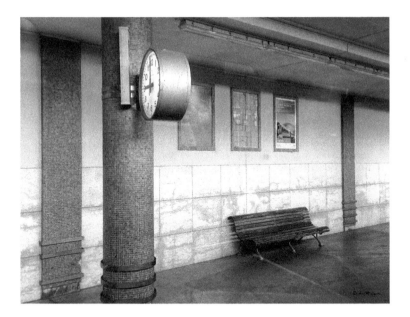

Time Out

Pondering And Penning

Time Out

From The Bench: An Invitation

Have you ever noticed that some benches have nameplates, some have quotes and others denote the locality? I say you just sit down, hang up your own imaginary nameplate and declare "today, this is my bench and my invitation." And then seemingly, if only for a brief time, it will become yours. So what will you make of the invitation? Seize the occasion, get out that journal, and ponder and pen. After all, it is your time on your bench with your name on it!!!

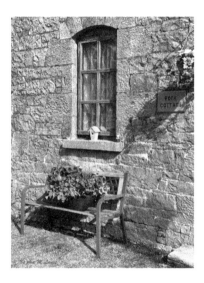

An Invitation

Pondering And Penning

An Invitation

From The Bench: A Rock Solid Day

"You are never so strong as when you have clearly in mind your successes." You can go to the bench and have a rock solid day if you just the think about the above quote. What are your successes? What goals have you met? When have you been the proudest of yourself? What talents do you possess? Deliberate on the questions, document them in your journal, take the initiative to act upon them, and see where life takes you. At the very least, reflecting upon them from the bench will yield a rock solid day.

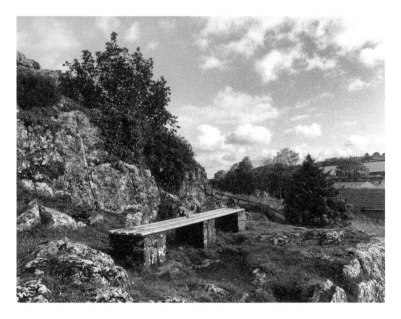

A Rock Solid Day

Pondering And Penning

A Rock Solid Day

From The Bench: From The Outside In

Looking at life from the outside in sometimes seems overwhelming and unbearable. But you have power over your mind. Realize this and you WILL find strength. So, instead, begin each day from the inside out - pay attention to who you are and what matters to you and intestingly enough, the outside world looks different. After all, it is your perspective and perception that matter!

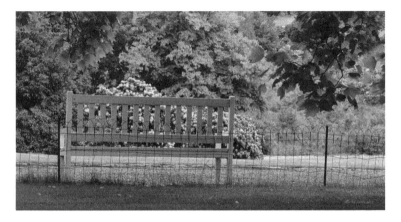

From The Outside In

Pondering And Penning

From The Outside In

From The Bench: Solitude

Winter brings its own set of remarkable wonders. Bundle up, pour a cup of hot chocolate, and perch yourself on a bench in the midst of the glistening snow....preferably under a shelter, but if not, just go for the gusto and feel the snowflakes on your face. Appreciate the remoteness of it all and heed the undisturbed snow cover. One can easily engage in contemplation as to the changing seasons and the miracles of creation. Winter can be especially captivating and can redefine the meaning of solitude. Winter, at times, makes it appear that the world can truly be still.

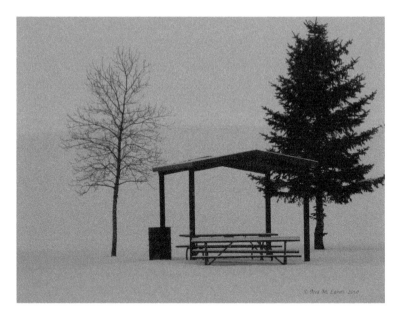

Solitude

Pondering And Penning

Solitude

From The Bench: Room For Others

Often, when we imagine a bench, we speculate that it is only a time for oneness. However, we should always be open to the idea of making room for another. Sometimes, an invigorating and enlightening conversation can occur when we least expect it. Or, if not a conversation, a time to observe and contemplate what might be occurring in another person's time and space. Subliminally, we can learn from each other, whether verbally or nonverbally. Let the time on the bench unfold… but always be open to making room for others.

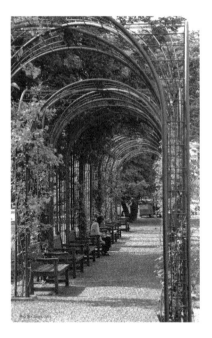

Room For Others

Pondering And Penning

Room For Others

From The Bench: Reflections

Reflections of objects (i.e. trees, flowers, birds, benches, skyscrapers or perhaps, even yourself) on the water can be absolutely eye popping and eye stopping. In fact, depending on the time of the year, the time of the day, the brilliance of the colors, the unique shapes and sizes, reflections can bring up images that are real or surreal. No matter the image, it can be a perfect time to express what you see in the moment or to cast back or to cast forward what is seen. As you reflect upon yourself, what becomes clear to you?

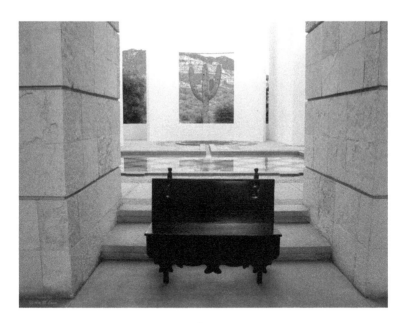

Reflections

Pondering And Penning

Reflections

From The Bench: Cultivate Happiness

When you find something that feeds your soul, care enough about yourself to make room for it in your life…. cultivate it and make time for it and make time for you. Cultivate it even if it is something so uncomplicated as sitting among the flowers, or placing your feet on a clump of green grass or gazing at a butterfly as it gently waves its wings in front of you. Be unpretentious, smile from the inside out and take pleasure in moments that feed your soul.

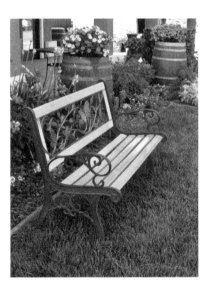

Cultivate Happiness

Pondering And Penning

Cultivate Happiness

From The Bench: What Sets You Apart

You are a unique individual, a person like no other. Bring to light your unique and positive characteristics. An author by the name of Donald O. Clifton in his book, <u>Soar With Your Strengths</u> says, "find out what you do well and do more of it. Your weaknesses will never develop, while your strengths will develop infinitely." So, take a seat on that bench, ruminate on your strengths and understand that you might just soar when you discover what sets you apart.

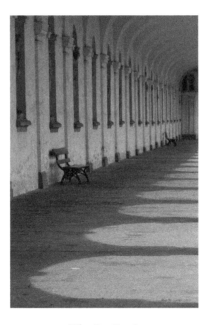

What Sets You Apart

Pondering And Penning

What Sets You Apart

From The Bench: Idle Time

The person you are with is busy shopping and you just want to take a break. So, you find the closest bench and plop yourself down. And then you wait. Oh, you think to yourself, maybe it's time get into the observation mode and do a little people watching. Wikipedia says people watching is the act of observing people and their interactions. It involves picking up on others idiosyncrasies and trying to guess another person's story. There is much to be gained by surveying others and there is much to be learned by seeing your reflection in the stories of others. Idle time can be a story time - yours or someone else's.

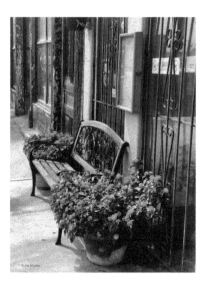

Idle Time

Pondering And Penning

Idle Time

From The Bench: Surrender To The Wind

Go for a hike, climb that tree, smell that flower and park yourself on that bench! Experience nature to the fullest and surrender yourself and your thoughts to the wind. For some of us, the wind whispers words of wisdom and makes us feel alive. It can give rise to a sensation of personal freedom, of untapped energy and of prevalent purpose. Allow your expressions to flow, your spirit to take flight and grant yourself the luxury of time to ponder and pen.

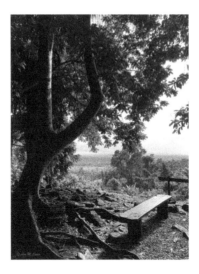

Surrender To The Wind

Pondering And Penning

Surrender To The Wind

From The Bench: The Long View

Life passes, seasons change, hair grows gray and hopefully, we continue to blossom, prosper and emerge into the person we long to be. We live in the present, but most of us keep our eye on the long view…..where we want to be in 5 years, 10 years and 20 years. And so we think about aspirations, we set goals and our ambitions begin to play out. If we start pondering and penning now, and recording those goals/aspirations, we can look back and muse over where we have been, where we are now, and where the long view might take us. Journaling from "The Bench" is the beginning of that personal archive.

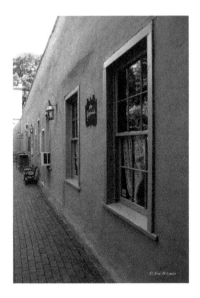

The Long View

Pondering And Penning

The Long View

From The Bench: From Where You Sit

So I began this book, "From Where I Sit" and now I conclude it "From Where You Sit." It matters not where you live or how old you are or the color of your skin or if you are rich or poor. What matters is that you know who you are, like who you are, know what you stand for, and mostly, that you have purpose in life "**From Where You Sit.**" Signing off..... FROM THE BENCH. AVA LANES, AUTHOR AND PHOTOGRAPHER.

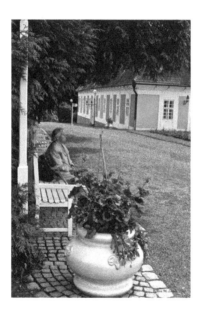

From Where You Sit

Pondering And Penning

From Where You Sit

CPSIA information can be obtained
at www.ICGtesting.com
Printed in the USA
LVHW072339310820
664725LV00030B/2001/J